SALTAIRE
HISTORY TOUR

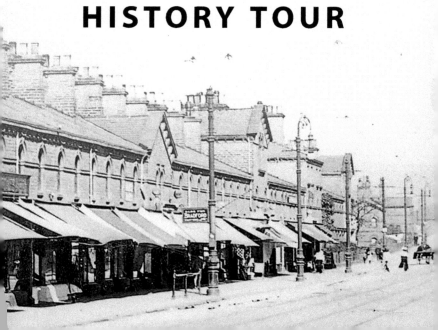

First published 2018

Amberley Publishing
The Hill, Stroud,
Gloucestershire, GL5 4EP
www.amberley-books.com

Copyright © Gary Firth, 2018
Map contains Ordnance Survey data
© Crown copyright and database right
[2018]

ISBN 978 1 4456 7472 8 (print)
ISBN 978 1 4456 7473 5 (ebook)

British Library Cataloguing in
Publication Data.
A catalogue record for this book is
available from the British Library.

Origination by Amberley Publishing.
Printed in Great Britain.

INTRODUCTION

I was born on the doorstep of this 2001 World Heritage Site in the middle of the twentieth century. Much of my childhood and formative years were spent at the homes of both sets of grandparents, who lived and worked in the village prior to the Second World War. My university undergraduate thesis was inevitable as I tried to make sense of this Victorian 'utopia' favoured by my maternal grandparents on the one hand but held in somewhat lower esteem by my father's parents. Here I shall dwell briefly on Titus Salt's lifetime achievements already covered by a host of biographers, historians and social history commentators who have told and retold the romantic story of Salt's rise from humble Yorkshire origins to his inclusion into the pantheon of successful mill owners and businessmen of the nineteenth-century Industrial Revolution. The best of these are Jack Reynold's definitive *The Great Paternalist* (1983), and my own *Salt & Saltaire* (2001) should also help the reader fill any gaps about the man and his times.

The main purpose of this publication, however, is to provide for the visitor with a guided trail of Saltaire's social, historical and architectural past. Only two of the public buildings – Sunday School (1972) and Wash House (1936) – have departed from the model townscape that Salt created in his lifetime (1803–76). Also, one or two cottages have been sacrificed to modern-day health and safety laws. The footbridge that replaced the solid cast-iron metal-fatigued bridge across the

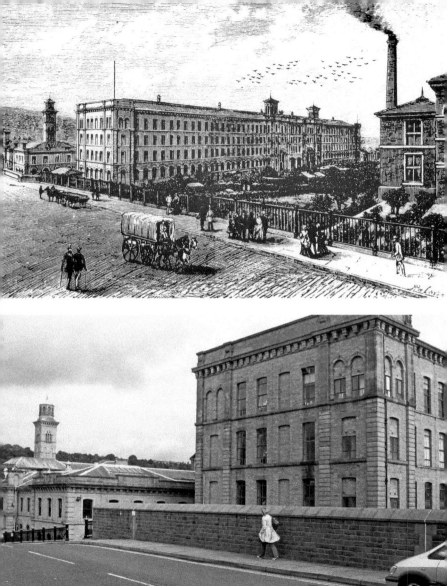

River Aire might have disappointed Salt due to its lack of grandeur; ditto for the new Wesleyan Chapel on Titus Street.

Only Albert Terrace retains the setts and cobbles of Salt's original highways and side streets. On the credit side I am sure Salt would have been the first to applaud the 1993 telecommunications installation (to those who approved). Private ownership and environmental changes like these have occurred in my lifetime of walking the streets of Saltaire. During that time, over four decades, I have guided walking parties of all ages, genders and abilities including WEA, Leeds University extra mural classes and Bradford University Continuing Education classes, dozens of local school parties, WI, rotary, and local history groups from across northern England, USA and Norway have followed me round its streets. When Amberley Publishing suggested a trail for Saltaire I jumped at the opportunity, particularly as I had coached a local authority blue badge guiding course for the city of Bradford and forgot to certify myself!

While teaching at Bradford College I was able to continue 'trailing' students and introduce them to Saltaire until my retirement in 2000. As a result, this publication has been long in the making and has been carefully modified over several years.

The trail is constructed around ten spots in the town, located at strategic stopping points where Salt's model village can be safely and contextually considered and understood by factual information and observational directions. These signposts and directives of the trail appear in an italic font throughout. The typescript of this publication need not be religiously adhered to. The opening hours of the mill and the Congregational Church should be confirmed prior to any visit. There is also a helpful information board and a large-scale map of the village in the car park, which is the starting point of the trail.

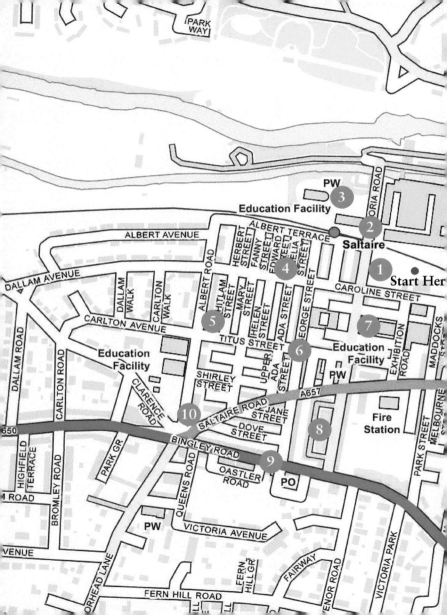

1. SALT'S SUNDAY SCHOOL

Our trail begins at point No. 1 on the map. This is located at the public car park and toilets in the centre of the village, adjoining Caroline Street and Victoria Road, the main highway of the village.

This location was formerly the site of Salt's Sunday school. You should now be standing opposite the huge south-facing frontage of Salt's giant mill. The site chosen by Salt and his architects in 1850 was alongside the River Aire on the site of the Dixon Mill estate of Mr Stansfield of Esholt Hall. This was originally situated between the Shipley–Bradford turnpike road and the Leeds–Liverpool Canal (1777). This important and practical transport infrastructure was completed only four years prior to Salt's arrival (1846) with a railway between Skipton and Leeds, later the Midland Railway. It is now a popular commuter line to Leeds and Bradford. You might be lucky to see a train passing by to demonstrate the close proximity of the line to the mill.

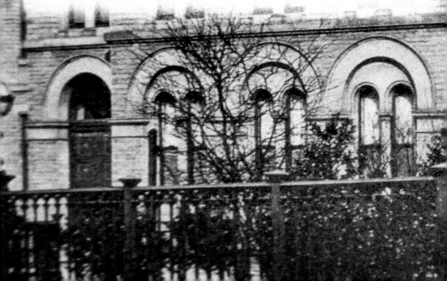

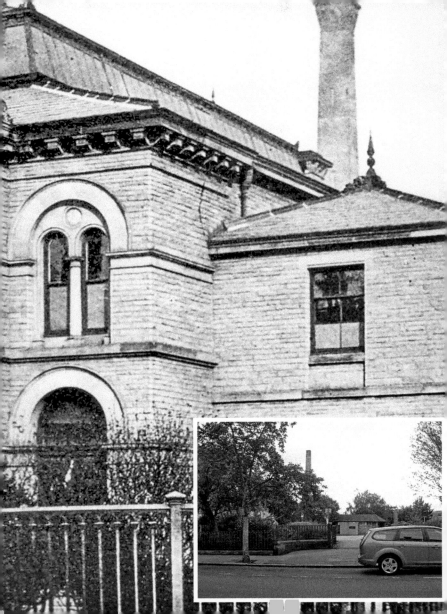

SALTAIRE MILLS

At the time, William Fairburn was considered the best textile engineer of the day and he was responsible for all the engineering work on the mill, including its four huge powered beam engines driven by a gargantuan boiler. Cast-iron columns supported each of the mill's six storeys. Between them beams supported arches of brick. The roof is built of iron and the outside walls permit a good flow of fresh air throughout. The mill cost Salt, in total, £100,000. Architects Lockwood and Mawson were responsible for the Italianate appearance of the mill's exterior with its twinned lanterns on this southern side, as well as its Tuscan chimney (now gone).

The mill was officially opened on Salt's fiftieth birthday in September 1853. It had taken three years to complete, about the same length of time taken by Bradford MDC to build the toilet block just 10 yards beside you. The mill today contains the 1853 gallery and much of the work of David Hockney.

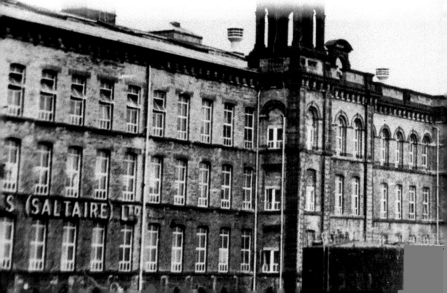

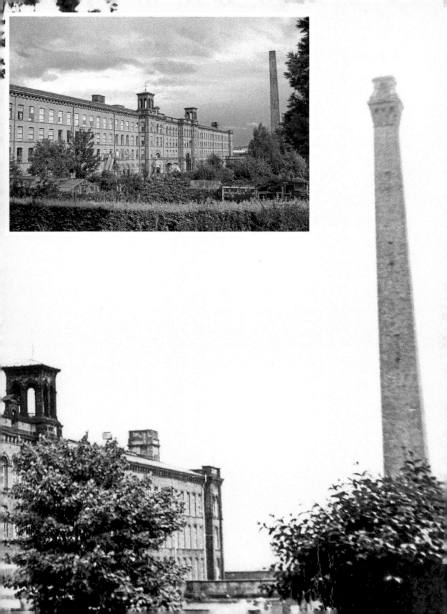

2. VICTORIA ROAD

We now move onto point No. 2 on the map by taking the exit from the car park opposite the parade of shops in Victoria Road. As you leave the car park cast your eyes to the roofline of the shops and note a third storey in the centre of the row. This was built in 1853 as a temporary institute and community centre until the erection of the Victoria Institute in 1871.

ALBERT TERRACE

On leaving the car park turn immediately right and cross Victoria Road to congregate at the junction with Albert Terrace. This is point No. 2 on the map, which overlooks the railway line and its station. You will recognise Albert Terrace by its distinctive cobbled stone setts.

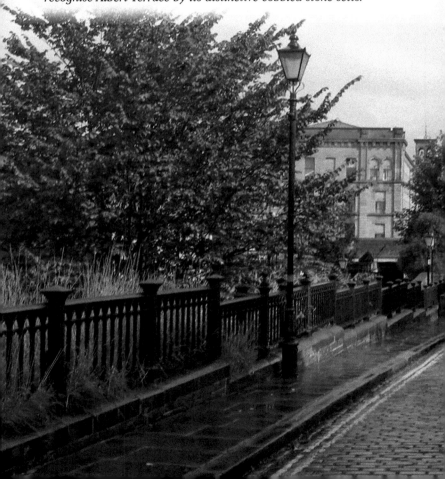

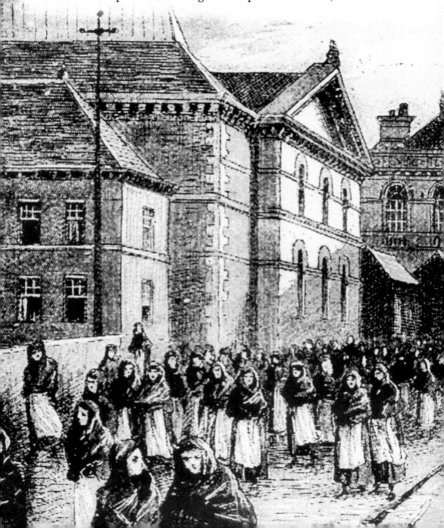

VICTORIA ROAD

An artist's impression looking south up Victoria Road, *c.* 1880.

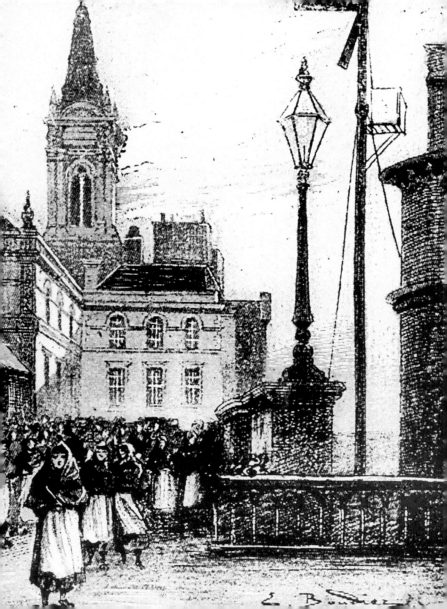

VICTORIA ROAD

A contemporary image looking south up Victoria Road.

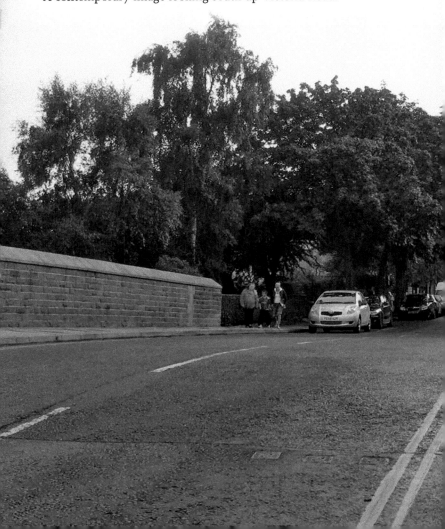

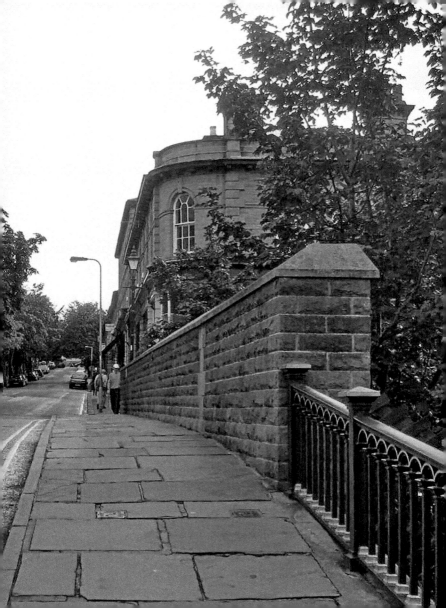

WILLIAM HENRY STREET

Amble now into Albert Terrace and soon you will see to your left William Henry Street and George Street, two of the earliest streets where the cottages have small apron gardens (for overlookers and departmental managers). These are repeated in George Street, which runs the whole length of the village like Albert and Victoria roads.

Following Salt's marriage to Caroline Whitlam, daughter of a Lincolnshire sheep farmer and a major contributor of Salt's wool supply, William Henry was their first child (born in 1831) but he came to have little interest in his father's business and lived the life of a country squire. Look at your map to see that streets leading off right and left from Titus and Caroline Streets were all named after their subsequent children: George (1833) Amelia (1836), Edward (1837), Herbert (1840) and Fanny (1841). These were the first of the workers' dwellings to be completed by 1854 at a cost of £120 each – i.e. between Caroline Street/Albert Terrace and between Herbert Street and Victoria Road.

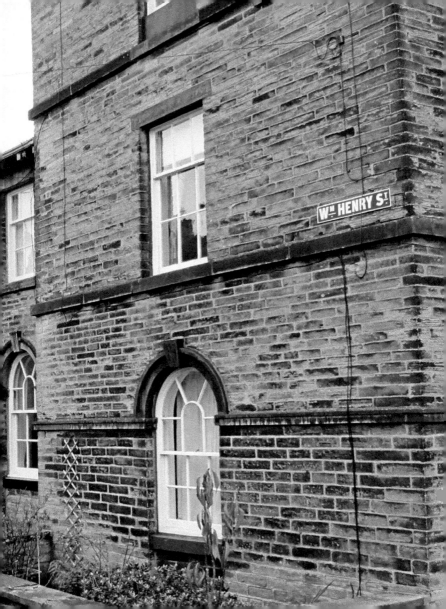

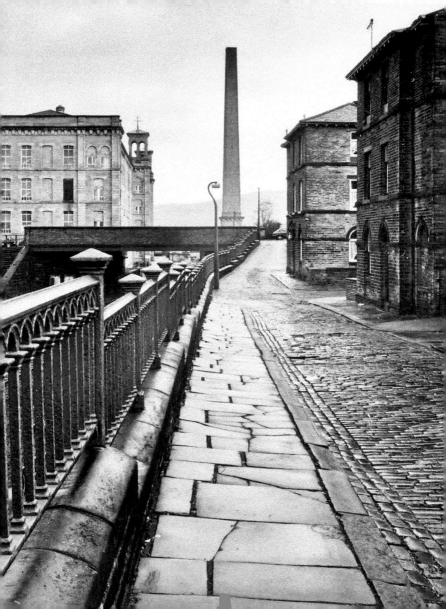

ALBERT TERRACE

From point No. 2, as you look along Albert Terrace in a westerly direction, you should note the three-storey houses at the end of each street overlooking the railway. Initially these were thought to have been boarding houses and were a considerable improvement on the poor-quality multiple-occupation homes in Bradford at that time (1850s). These were never popular with the early workforce, who preferred to lodge with friends or family members until acquiring a house of their own.

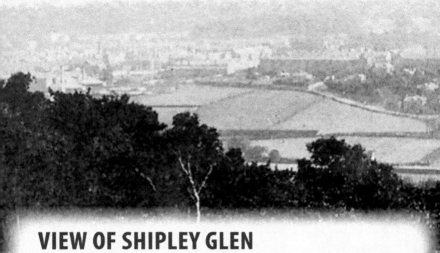

VIEW OF SHIPLEY GLEN

Before leaving point No. 2 look across the railway bridge and in the far distance is the sylvan beauty of Shipley Glen, part of the Yorkshire Dales.

Fresh air and clean water were high on Salt's agenda when he chose this location to build his model village. During his year as Mayor of Bradford in 1849 he had been appalled by the filthy and squalid living conditions of many of his Bradford employees. Coal-fired mills and the hearths of an expanding population caused a smoky pall to settle over Bradford for the greater part of each day in those years. In addition, large numbers of disreputable brothels and beerhouses sprang up, offending Salt's Nonconformist upbringing and compromising the moral values of his own young family.

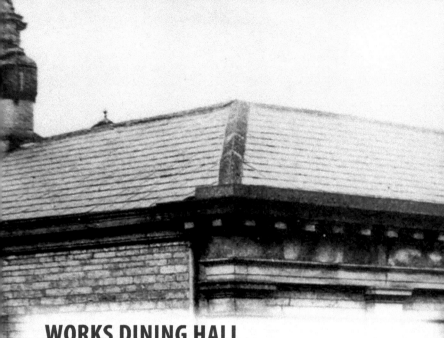

WORKS DINING HALL

Before we leave point No. 2 of the map, cross the railway bridge and on your left is the entrance to the railway station. Immediately on your left is the rather unprepossessing building of the Works Dining Hall, built in 1854.

This originally catered for those who travelled to work in the mill from outside the village. Mill employees, however, could access it by a tunnel (which is still there) beneath the road leading from the mill yard opposite. This building cost Salt £3,600 and it could cater for 800 diners at one sitting. Meals were not free but basic food and drink could be purchased cheaply. By 1900 most employees chose to eat at home. Above the doorway of the building spot the large stone medallion bearing Salt's coat of arms.

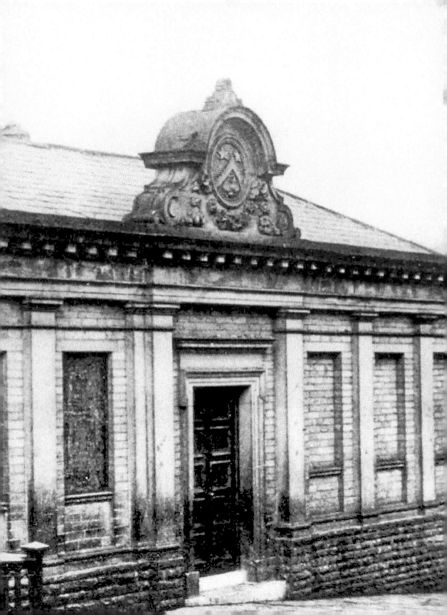

VICTORIA ROAD (LOWER)

We are now keeping to the left side of Victoria Road and heading north towards the river in order to reach point No. 3 on the map – the Congregational Church.

Before reaching point No. 3 cast your eyes across Victoria Road to where the north side of the mill reveals the wool-combing shed, weaving mill and directly in front of you at ground level the office block – Salt's personal and private entrance to the works as well as the boardroom of the business. The corniced roofline supports three bell turrets (from pre-buzzer days) when the workpeople in their thousands were summoned and dismissed to and from their shift work.

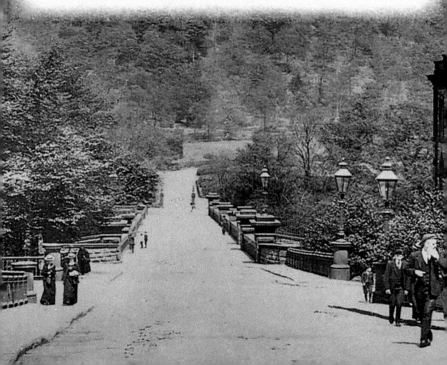

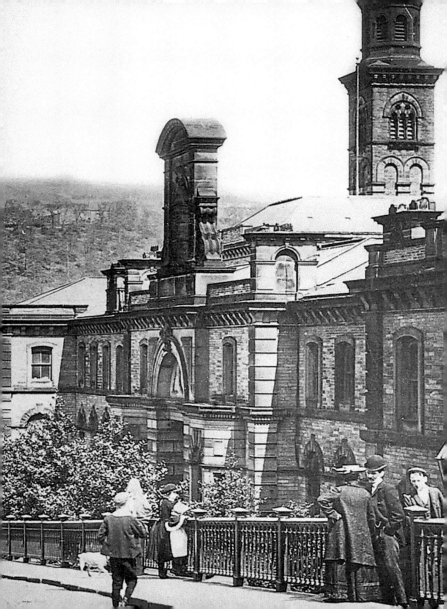

3. CONGREGATIONAL CHURCH

Beyond and opposite the office block on the other side of the road is our third location on the map – the Congregational Church. This was the first public building to be completed in the village and was deliberately sited opposite the mill.

The Congregational Church was opened in 1859 and cost Salt £16,000. It was built in the classical style of Lockwood and Mawson. It seated 600 worshippers and regularly accommodated 400 whenever Salt and his family attended in their balcony pew. It later became a United Reform church. Inside, the decoration is understated: there are no aisles but huge pilasters of green scagiola soar up to the ceiling. On the southern side of the church is the Salt family mausoleum, which can be accessed from within the church. The domed tower of the church stands on a semicircular portico of huge Corinthian columns.

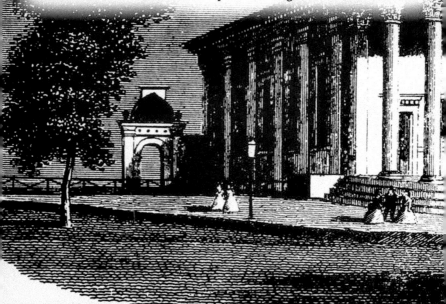

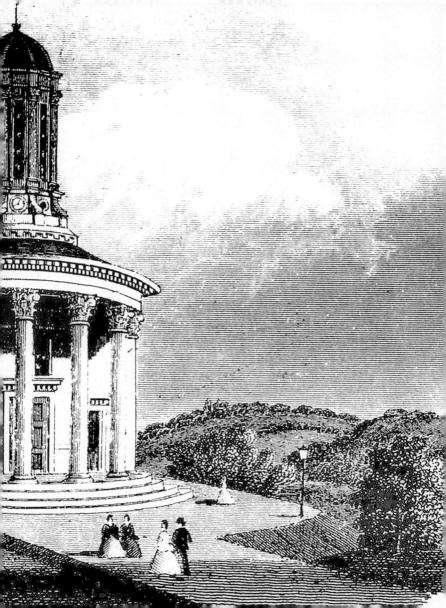

SALTAIRE PARK

Looking left from the entrance to the church you can take in Salt's 14-acre park, half of which was taken up by a cricket field. There were also opportunities in the park for employees to engage in recreations such as croquet, tennis, angling, boating and swimming. The park was opened in 1871 and the grounds were laid out with shrubs, trees and exotic plants interwoven by a number of walks and avenues, a central promenade and a half-moon pavilion providing refreshments. Nearby is an adventure playground for children provided by Bradford MDC in recent years.

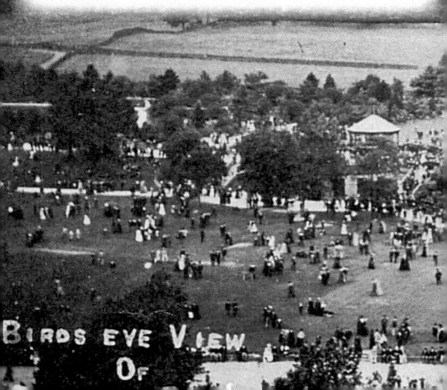

BIRDS EYE VIEW OF

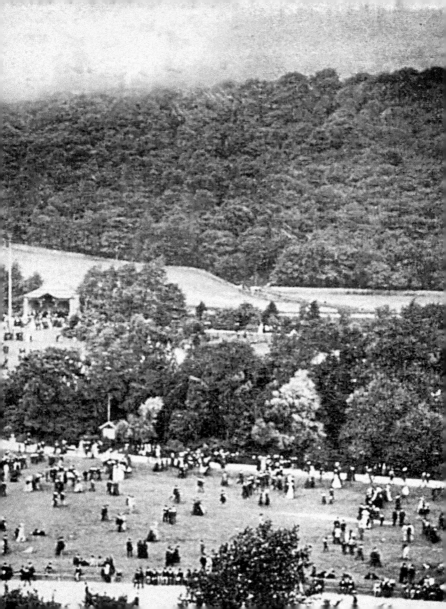

PARK LODGE

Life at Saltaire was not all work and industry. It was somewhere the villagers could play, relax and wind down, but were still controlled by social discipline and a set of rules about public behaviour; for example, stone throwing, football, discarding orange peel and smoking in the alcoves of the park were all forbidden. Unaccompanied children under eight, swearing, and drinking alcohol were all prohibited. The park kept strict opening hours signalled by yet another bell in the tower of the park lodge.

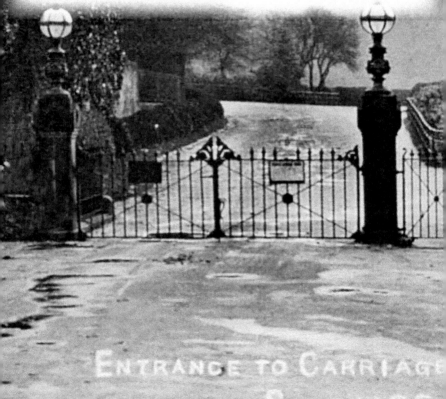

4. SITE OF THE OLD WASH HOUSE

Now retrace your footsteps back to point No. 2, turning right along Albert Terrace (take care where you walk as Salt's workpeople were not pestered by dogs as we are today and on rainy days the cobbled surface can be slippery). Walk along the terrace in a westerly direction then turn left into Amelia Street and head towards Caroline Street until you access an open area to your right. You are now at our fourth stop, an open garden square to sit and reflect on what you have seen so far.

BATHS AND WASH HOUSE

Here on this spot on 6 July 1863 the baths and wash house were opened, which were open every day from 8 a.m. to 8 p.m. Illustrations of this now demolished building are displayed on a helpful information board in the square nearby.

The cottages of the workpeople were not equipped with running water nor a proper sanitation system. However, night soil was removed from the privies outside each house without passing through the house itself. The wash house project cost Salt £7,000 to build, but it was not a success as most people preferred to wash clothes and bathe in the privacy of their own houses. For those who scorned such niceties there were twelve male and twelve female baths with different entrances, and for those who could afford it and with social aspirations, a Turkish bath was provided. For laundryware, forty-eight coppers (large heated tubs) were provided with mangles along with numerous heated drying racks. The bathhouse was partially demolished in 1894, although some parts of it were retained and converted into cottages after 1900. Salt personally did not like to see washing lines in the street and he apparently frowned on those who were found using a mangle any later than Thursday of the working week. All self-respecting women washed on Monday, ironed on Tuesday etc. The original building of the wash house is thought to have been in sympathy with the Italianate style of the whole village. An old plan (there are no photographs surviving) suggests a colonnaded frontage facing onto Caroline Street and topped by a small campanile in the classical style.

To the right is a conjectural image of the wash house drawn from an architect's plan.

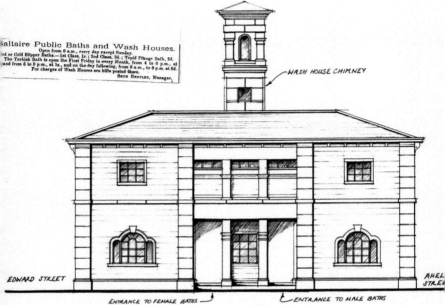

WASH HOUSE CHIMNEY

EDWARD STREET

AMEL STREE

ENTRANCE TO FEMALE BATHS

ENTRANCE TO MALE BATHS

CAROLINE STREET

AMELIA STREET

Before leaving, take a closer look at the cottages at No. 1 Amelia and No. 1 Edward Streets. They are typical of the original first phase of housing up to 1854. They are all through terraces with a yard and a privy. Each house had a set pot to heat water and a 'York' oven range in the living room. By modern standards they seem small and plain, but importantly none were back to back. Their typical layout had a living room, small kitchen/pantry and a downstairs cellar. The standard cottage cost Salt £120 each. It had at least two bedrooms, each of which had a fireplace. At No. 1 Amelia Street you will notice that a bedroom has been converted into an inside bathroom. This was certainly the case at No. 58 George Street, where my grandparents took advantage of Mr Guild's generosity in 1933 when instead of paying a weekly rent they were allowed to buy their house outright and do with it as they saw fit. The first tenants had paid a weekly rent of only 2s 4d back in the 1860s.

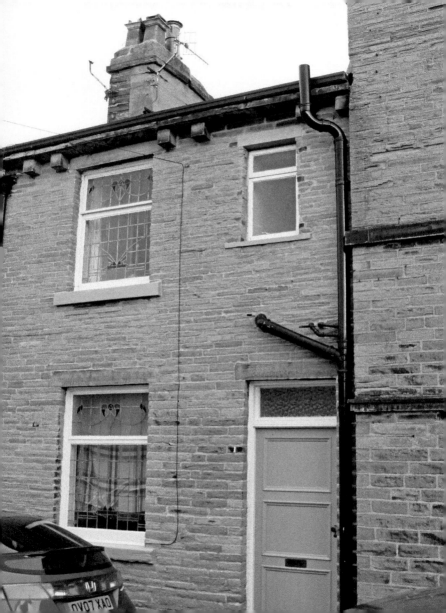

VIEW LOOKING NORTH DOWN ALBERT ROAD

Now continue the trail by walking westwards along Caroline Street towards Albert Road, which marked the western boundary of the village. At the junction of these two streets turn left up Albert Road (completed in 1868 as part of the final phase of housebuilding). Had you turned right at the end of Caroline Street, heading back towards the railway, you might have noticed that the houses at the bottom of Albert Road (see the following two pages) are in blocks of two and four.

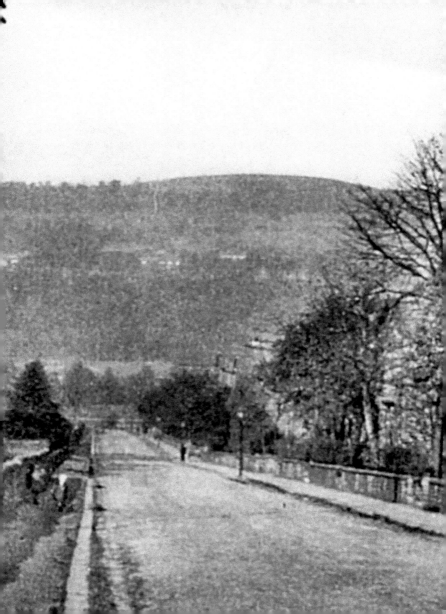

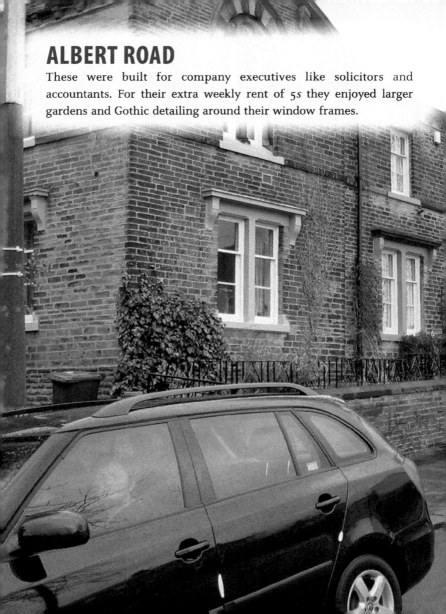

ALBERT ROAD

These were built for company executives like solicitors and accountants. For their extra weekly rent of 5s they enjoyed larger gardens and Gothic detailing around their window frames.

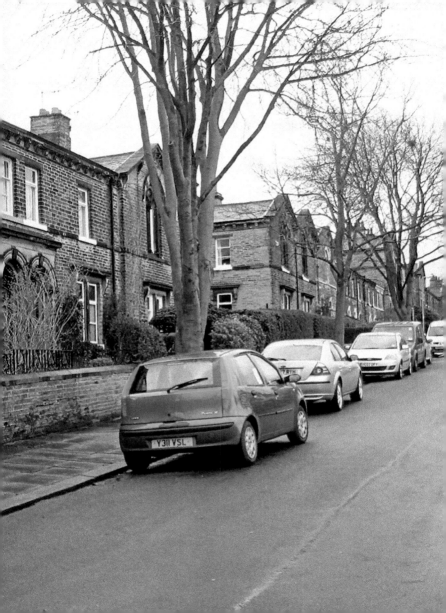

ALBERT ROAD

By turning left up Albert Road and heading towards Titus Street, you will eventually pass a row of eighteen overlookers' houses on your left, which in 1871 were homes for the congregational minister (a senior registrar of births etc.), two schoolteachers and various foremen from the works. Their homes then looked across green fields towards Nab Wood and apparently enjoyed enviable views of the setting sun across Airedale.

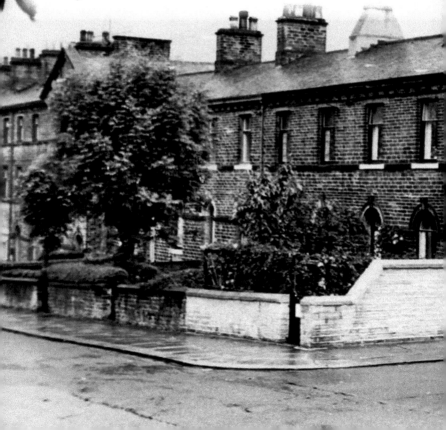

5. ALBERT ROAD AND TITUS STREET

At the end of the row of middle-class and professional family homes is No. 27 Albert Road, which also adjoins Titus Street. This site is No. 5 on the map.

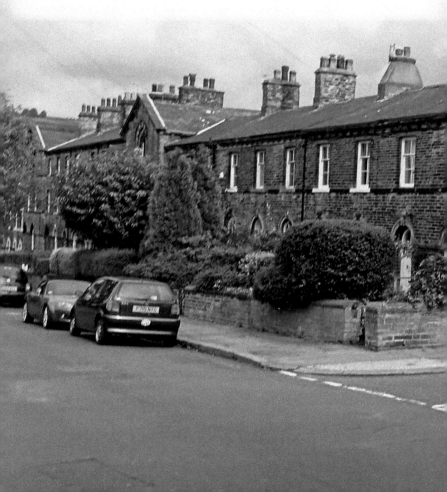

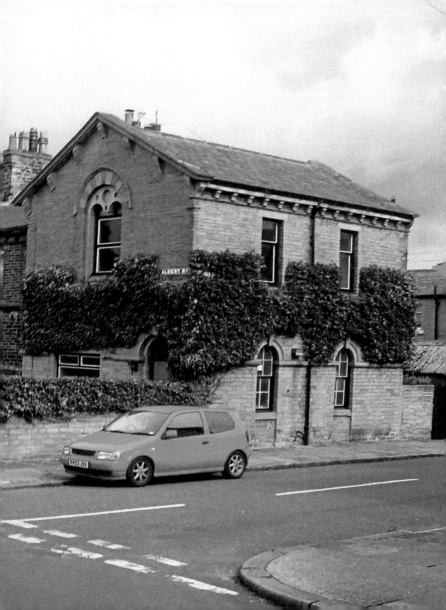

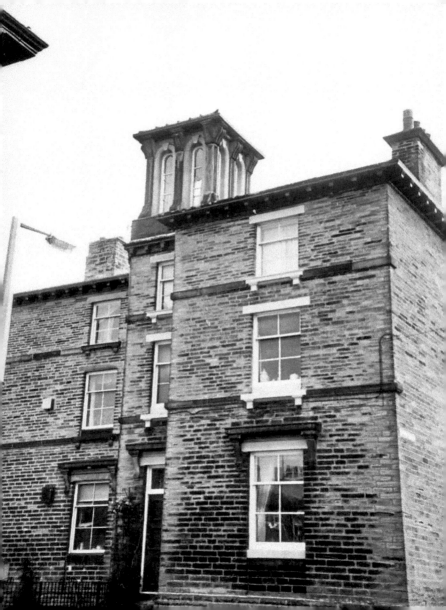

NO. 47 TITUS STREET

From here you should walk directly eastwards along Titus Street, pausing at the junction with Mary Street on your left where in the far distance on the skyline to the right a windowed viewing tower at No. 47 Titus Street can be seen.

The tower's purpose is in doubt. The house was occupied formerly by Sergeant-Major Hill, previously of Shipley police force. Villagers were naturally suspicious of his motives but as he was the security and fire officer at the mill, the viewing tower was probably nothing more sinister than a firewatch for the village. At the junction with Upper Ada Street, you will notice that the houses between Titus Street and Leeds Road run parallel to Titus Street, rather than perpendicular as in the earlier building phases.

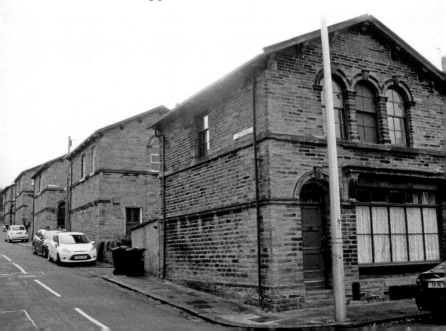

6. TITUS STREET SHOPS

Continuing eastwards along Titus Street, stop at the junction with George Street; this is point No. 6 on the map.

On this junction remain two of over forty corner shops that were in Saltaire in 1870. To the left is the Spa grocery and general store (formerly a wonderful bakery run by the Porter family in the childhood days of the author). Directly across from it is a walled-up shop frontage converted into a house (No. 48 Titus Street).

The image to the right shows another corner shop in Titus Street.

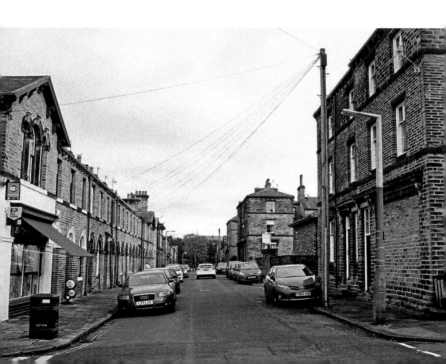

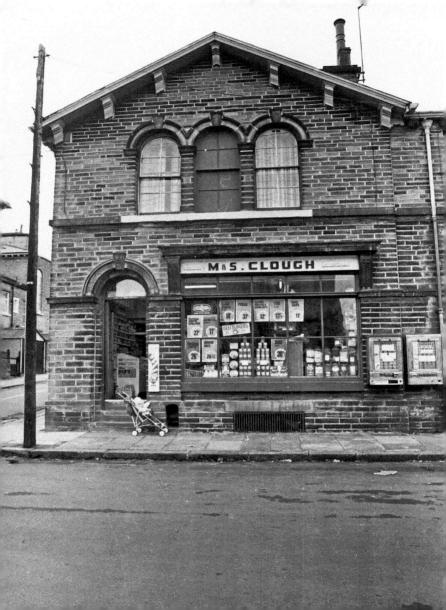

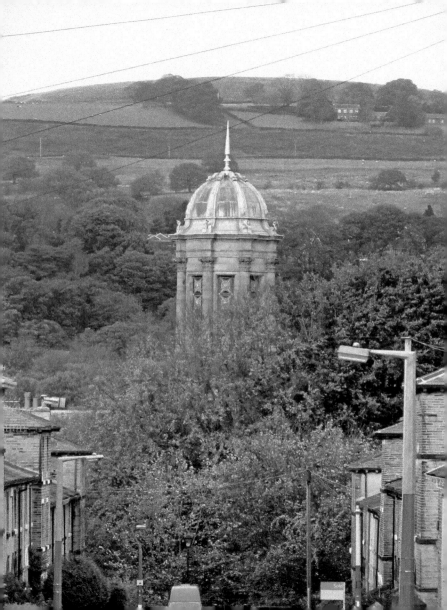

LOOKING TOWARDS CAROLINE STREET

Still at point No. 6, looking northwards down towards Caroline Street is a view of the magnificent church afforded to travellers on the Leeds and Bradford roads, taking in George Street, which runs the north–south length of Saltaire, like Albert and Victoria Roads (see map).

WESLEYAN METHODIST CHAPEL

Now it is time to leave the sixth stop by continuing along Titus Street towards Victoria Road, but not before bypassing the rear of the modern Saltaire Methodist Church on your right, which was originally built here in 1868.

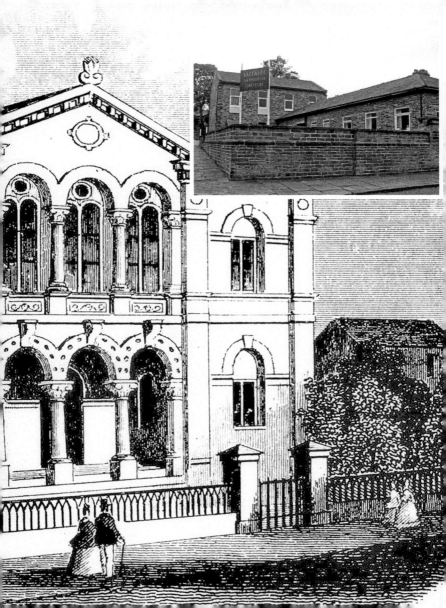

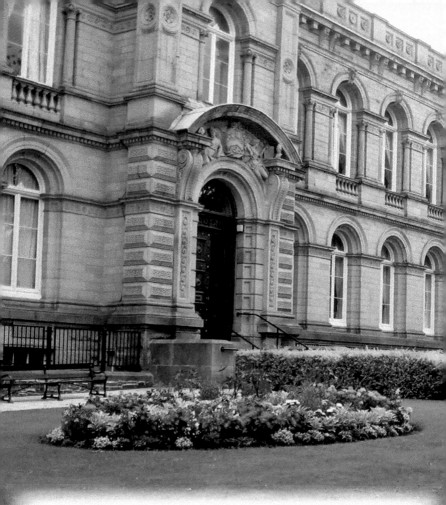

7. VICTORIA SQUARE

On reaching Victoria Road make an abrupt left turn into Victoria Square and across Victoria Road to point No. 7 of our trail.

VICTORIA SQUARE

The square is marked at the four corners by the lion statuary of Thomas Milnes. The lions represent War, Peace, Vigilance and Determination. They are thought to have been originally sculpted by Thomas Milnes for the Nelson monument in Trafalgar Square, London. This square is dominated by the Saltaire Club and Institute, which takes up the east side of the square and faces the Factory Schools.

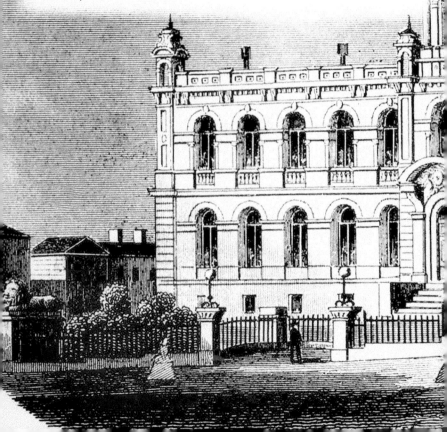

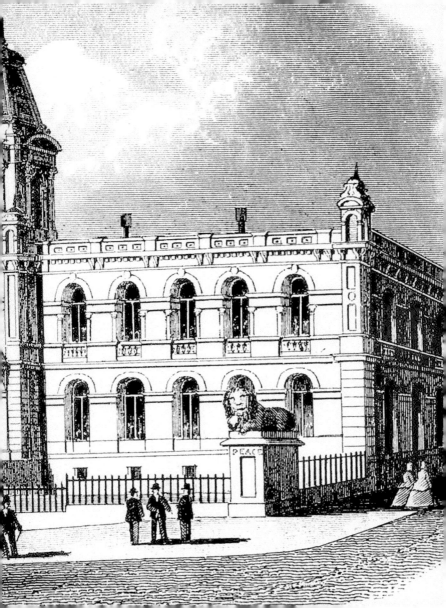

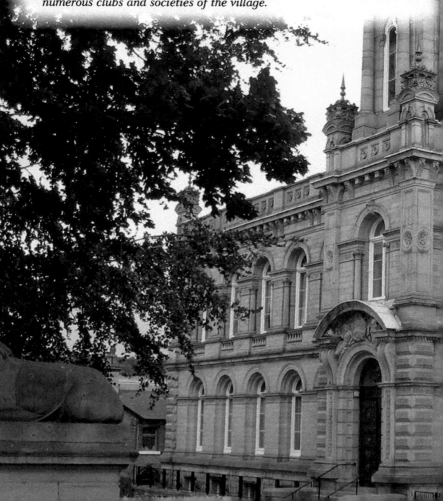

VICTORIA HALL

Stand at No. 7 beneath the main entrance to the Victoria Hall, which was completed in 1871 at a cost of £25,000 providing a home for numerous clubs and societies of the village.

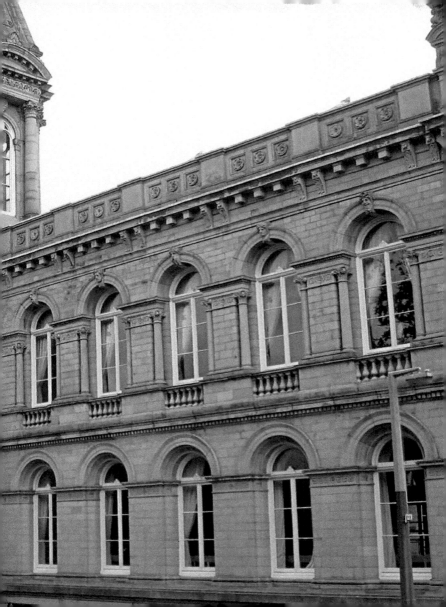

VICTORIA HALL

This building was to compensate for the lack of a public house in Saltaire. The stonework in the arching of the entrance above you hints at the importance of the School of Science and Arts established within as well as a free public library and literary society. Within the institute there was also a reading room, chess and draughts rooms, billiard tables, a smoking room, art room and below ground level a gymnasium, and finally Salt provided a drill room for the 39th West Riding Volunteers.

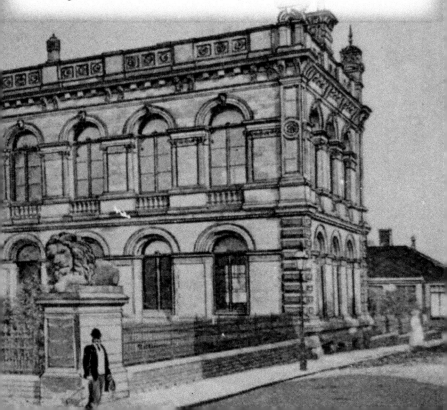

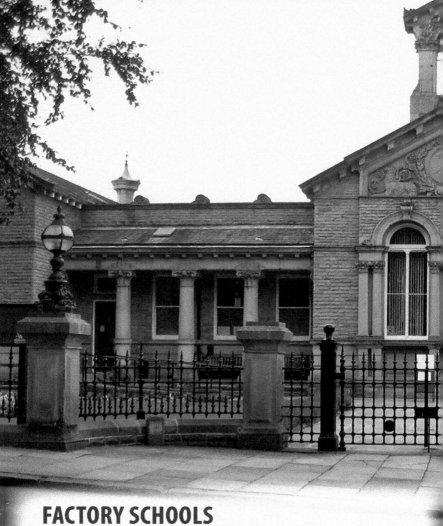

FACTORY SCHOOLS

Journey now directly across the Victoria Road to the entrance of the Factory Schools.

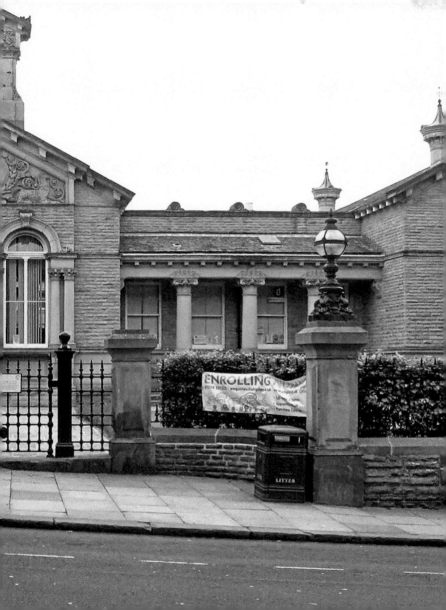

FACTORY SCHOOLS

This building replaced the mill dining room, which had provided elementary education to the children of the village since 1854. The school was built in 1868 to accommodate 700 pupils with separate entrances for boys and girls, many of whom were working at the mill part-time prior to 1876. There is a playground at the rear, which is overlooked by George Street.

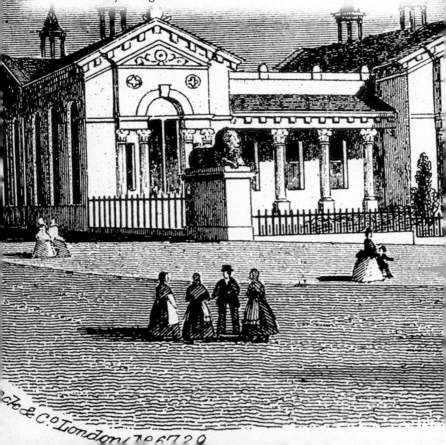

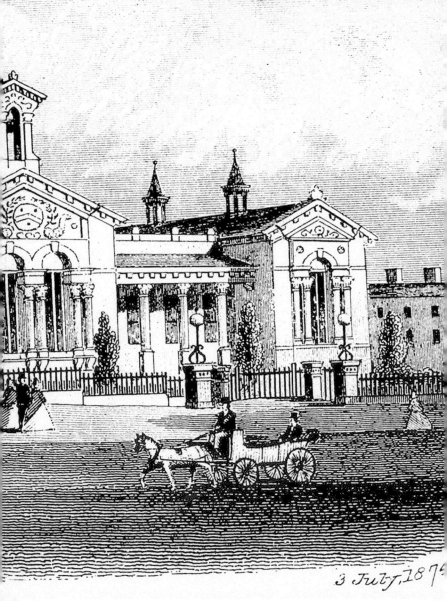

3 July 187?

8. ALEXANDRA SQUARE

Exit the school gates into Victoria Road and, turning right, retrace your footsteps towards Titus Street but continue towards the busy junction with Leeds Road and cross over by using the pelican crossing. Continue up Victoria Road turning until you reach point No. 8 on the map.

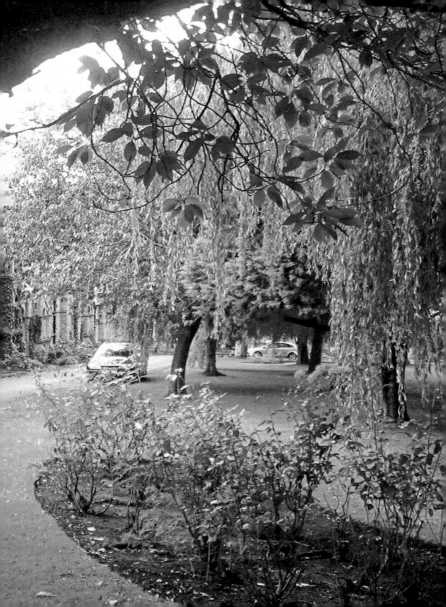

ALEXANDRA SQUARE

An artist's impression of the forty-five almshouses built for the elderly in the Venetian Gothic style. On the far right of this image the upper façade of the original Methodist Chapel can be seen.

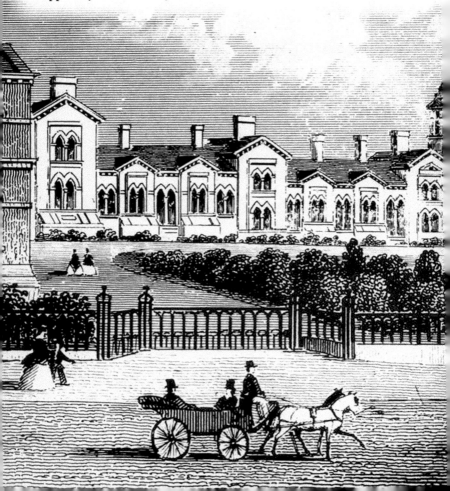

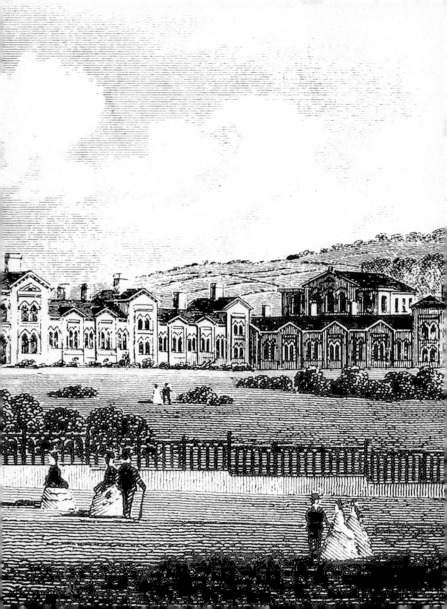

SALT'S HOSPITAL

Before entering the square you will notice Salt's Hospital on your left facing it, which opened in 1868 as a casualty ward for accidents at the mill. Originally the two-storey building housed just six beds. By 1909 a third floor was added and careful scrutiny of the façade and roofline will reveal the additional storey. Later extensions and the inclusion of four almshouses increased the capacity so that it became Shipley's main hospital for a greater part of the twentieth century. It finally closed in 1979.

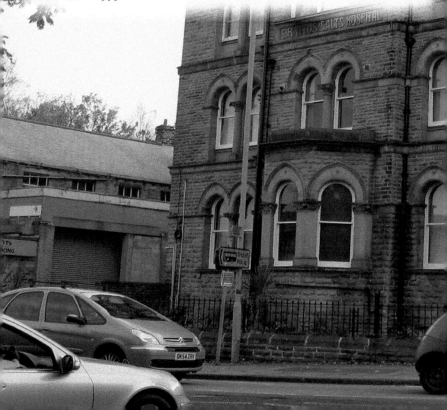

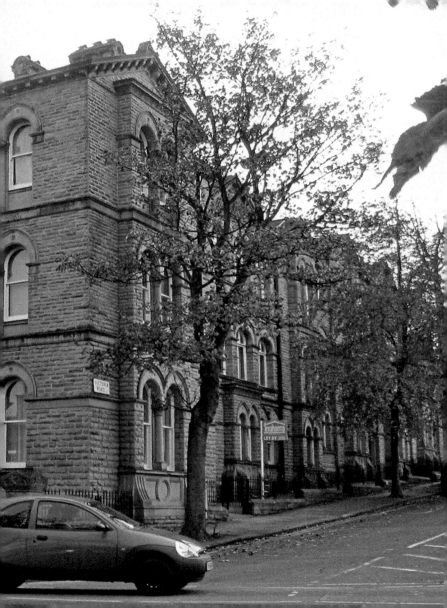

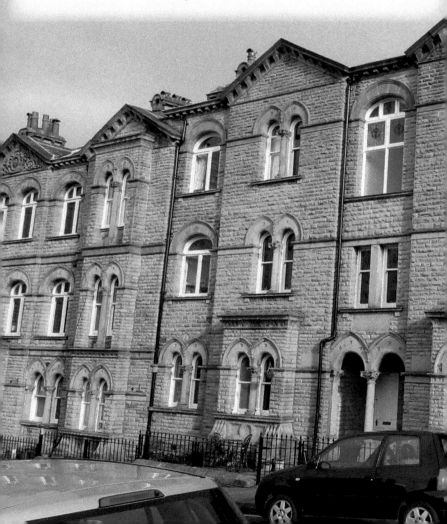

SALT'S HOSPITAL

A modern view of the hospital.

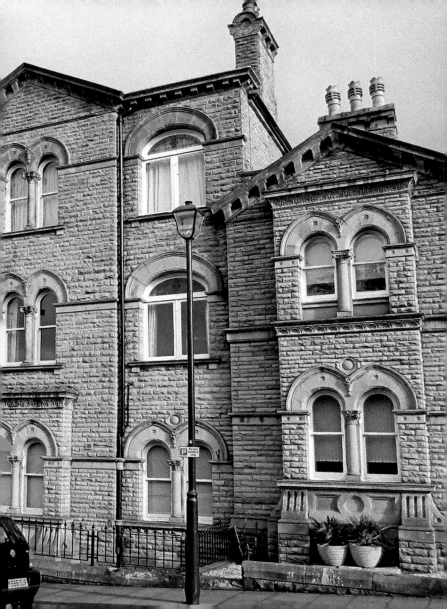

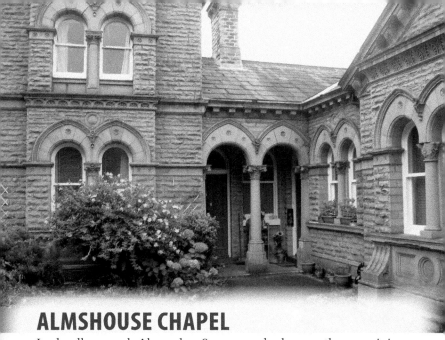

ALMSHOUSE CHAPEL

Look all around Alexandra Square and observe the remaining forty-one Italianate almshouses for Saltaire's elderly residents. A small campanile on the roof of the central cottage on the west side tells us they were opened in September 1868, and each cottage was provided with an oven, boiler and pantry with a single bedroom. The original capacity was planned for sixty residents, although there were originally forty-five homes (now forty-one) for former employees too infirm or diseased to carry on working. They were also required to possess a good moral character to qualify for their 10s weekly pension (7s 6d for the widowed). In an alcove in the north-west corner of the square is a small chapel for the infirm residents to attend. Also, halfway up the north-west side of the houses is an entrance that hosts two large stone tablets recording the earliest inmates of these homes (now under local authority control).

9. WESTERN END OF GORDON TERRACE

Leave Alexandra Square at its southern exit and follow Victoria Road to its junction with the Keighley–Bradford road. Turning right, walking in a westerly direction along Gordon Terrace towards point No. 9 on the map, you will pass twelve three-storey buildings erected in 1868. These were originally overlookers' houses with gardens, but were converted into shops in the early twentieth century in order to link into the parade of shops built as early as 1869 at the western end of Gordon Terrace, which adjoins Saltaire Junction. This marks our ninth stop.

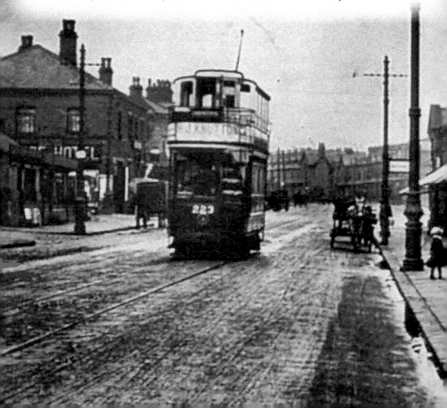

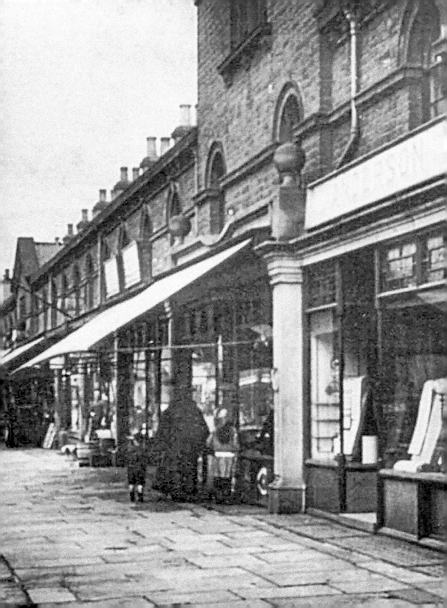

WESTERN END OF GORDON TERRACE

A look at the terrace today.

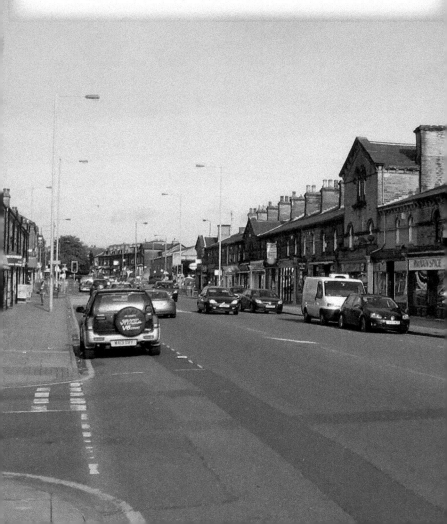

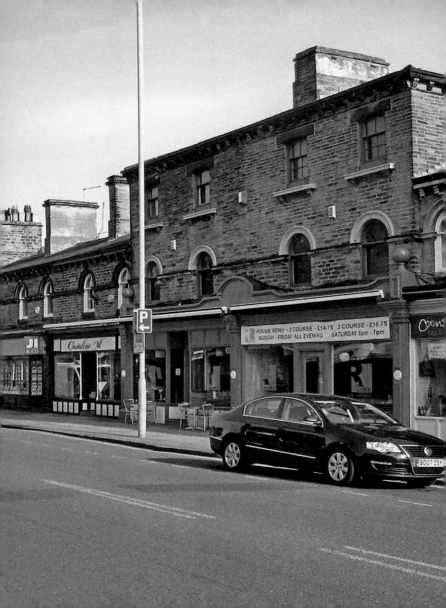

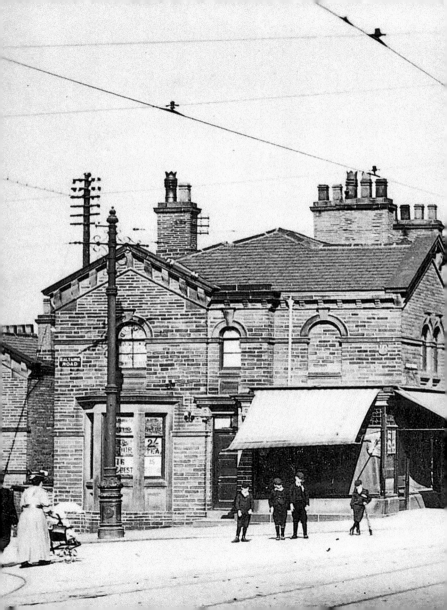

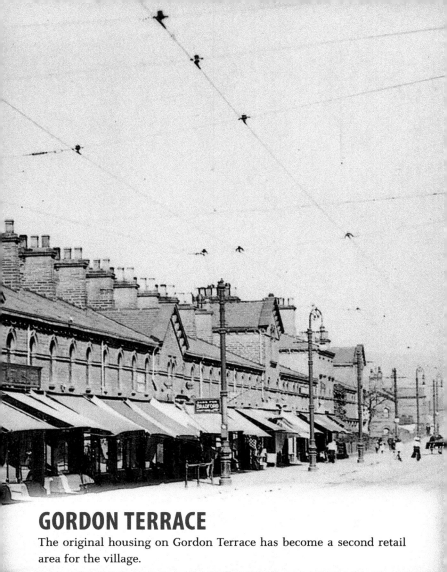

GORDON TERRACE

The original housing on Gordon Terrace has become a second retail area for the village.

CHARLESWORTH'S SHOP

This grocery store at the junction of Gordon Terrace and Saltaire Road was popular with Saltaire's Edwardian shoppers. John Charlesworth (outside his shop) had first begun retailing as a flour dealer at No. 1 Victoria Road in 1880. No. 24 Gordon Terrace served as an agency of the Halifax Building Society for much of the twentieth century, but has recently become 'Gourmet Corner', a delicatessen and café.

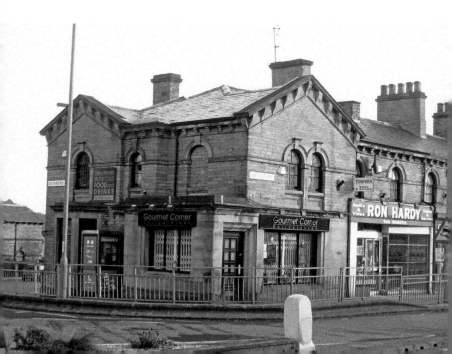

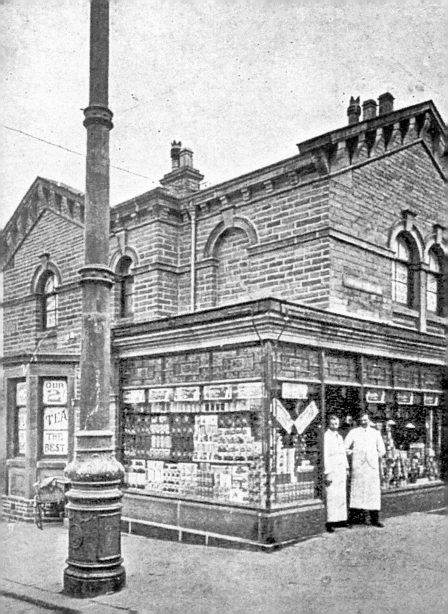

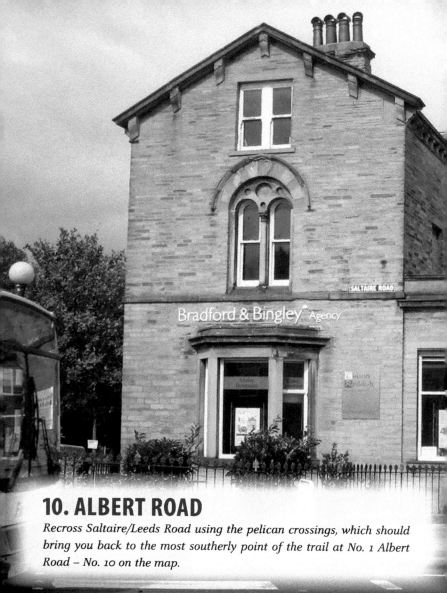

10. ALBERT ROAD

Recross Saltaire/Leeds Road using the pelican crossings, which should bring you back to the most southerly point of the trail at No. 1 Albert Road – No. 10 on the map.

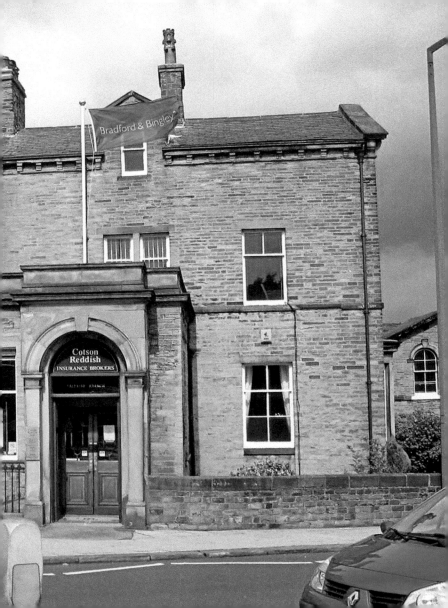

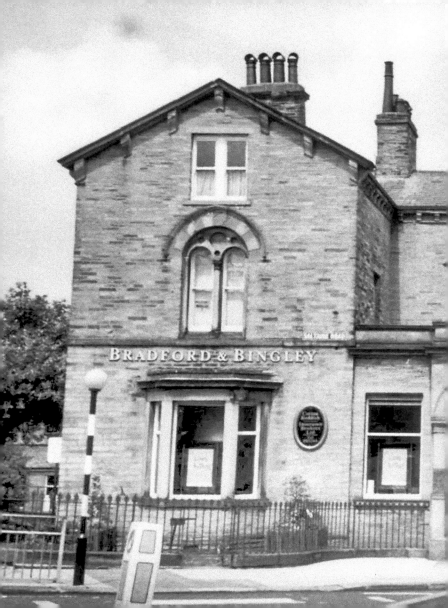

ALBERT ROAD

This was the largest house built as part of the original village. The 1871 census shows Fred Wood, the company's chief cashier, to be living here on a weekly rent of 7s 6d. For much of the last century it was a branch of Lloyds Bank.

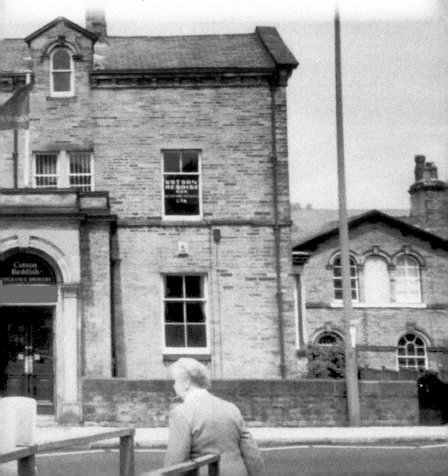

VICTORIA ROAD

A view northwards of Victoria Road, *c.* 1910.

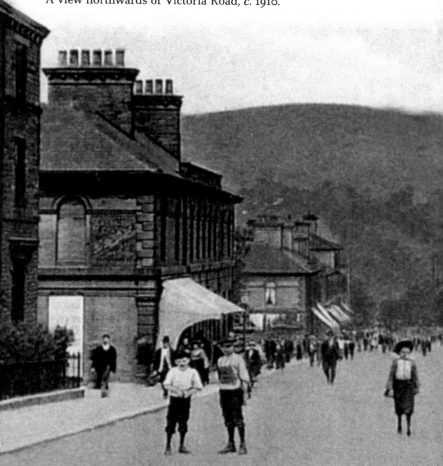

Victoria Road, Saltaire.

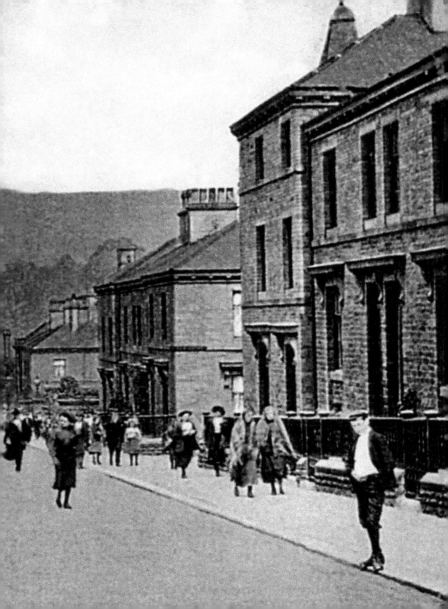

VICTORIA BRIDGE

A view east along the Leeds–Liverpool Canal of the New Mill around 1868. Boating from the boathouse at the bottom right of this photograph was a popular pursuit of visitors and residents up until the 1960s.

Our trail is now complete and you are free to return to any part of Saltaire's grid layout via Albert Road. Please remember to respect that people live here and their privacy should be acknowledged at all times.

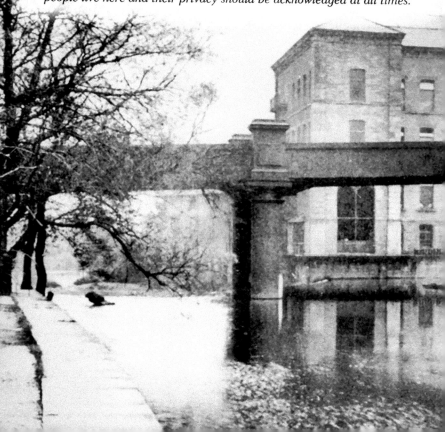

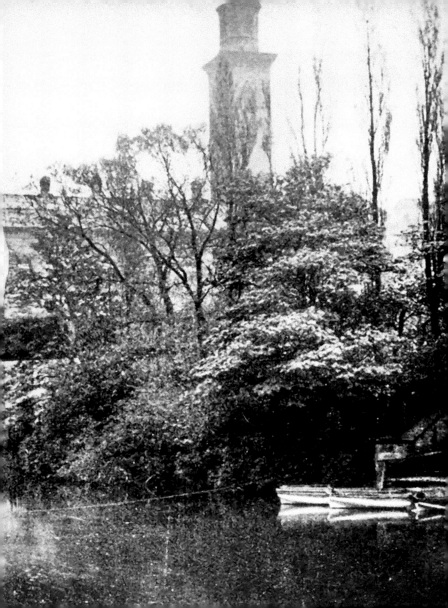

ACKNOWLEDGEMENTS

Thanks go to Rachel Slater and Marlene Sharkey for their assistance on the production of this publication.